BARZAGHI MARCO

SUCH AS TO GAIN WITH ART

Safe investments in art and beauty

Have you ever wondered how to make money easily?

There is no easy way, but we can guarantee you a brand new method linked to high quality durable goods that will guarantee you tranquility, a profitable insertion in the world of Art.

Before seeing in detail the new proposal we see briefly the other possible investments or gains that the market offers.

FIRST CHAPTER

The types of investments

The first simple way is renting a house.

it is a monthly income that brings you money without any effort whatsoever, at least in appearance.

But the negative sides are many, let's see them:

The rent is not guaranteed, if the tenant decides not to pay you will lose some money and you can incur even expensive damages if you oppose with force.

The house, however, requires constant and costly maintenance, administration and rent management costs and fees for paying taxes which in some countries are very high.

They require fire insurance costs, disasters and damage to people or things.

All these expenses greatly reduce income and make selling difficult.

As a whole it is a long-term and middle-income investment.

FINANCIAL SHARES AND INVESTMENTS

They are clearly speculative and therefore dangerous investments.

By admission of the same operators in the sector, 86% of the people who trade are at a loss.

Only this data strongly advises against investment.

Buying shares involves a knowledge of non-simple stock exchange rules.

Being a stockholder "drawer" for a long time could lead to a fair amount of money at the expense of their extreme or scarce availability of the amount invested.

If you sell at the wrong time, you can have colossal losses.

Keep in mind that any company goes on the stock exchange for cheap money and that only well-organized companies can give you satisfactory dividends and few real capital increases.

BONDS

both public and private bonds today give low interest, not tax-free, which reduces the already low yield.

They should be used to preserve a minimum of value for one's money, but known banking events around the world also make investments in bonds dangerous.

GOOD POSTAL ORCHARDS

Yields, if you can call them yields, of 0.1 or 0.35

German bunds almost zero while European bunds range from zero to 3%

US government bonds yield about 3% while stocks 1.7%

Italian government bonds yields from zero to 2.6%

TRADING

We have already excluded trading as an investment, due to its danger, using instruments that in other eras would have been censored with life imprisonment.

The typical volatility of these operations leads to excluding this investment as suitable for all fifths and is not recommended for everyone.

THE CRYPT VALUES

They are based on software, even sophisticated, which should guarantee security.

But today one thing is certain.

Any software or hardware is attackable and vulnerable.

Millions of scams per day for the cards that we all use, demonstrates the weakness of the software and the men who run them.

A census should be made of people who have lost money using cryptocurrencies to find out how and when they used them and how much they lost.

For now only the currency guaranteed by a public central bank that totally manages the use and the way of use can guarantee its value.

Private coins of any type and size, especially if managed by private banks, are considered dangerous and should be avoided using them and speculating on them.

BOATS, LUXURY CARS, COLLECTABLES, ANTIQUES

Investing in luxury, boats and cars, can be a gimmick for some companies to reduce the disbursement of taxes and for the private individual to increase his status symbol but does not save them from obsolescence or the danger of theft and disasters.

COLLECTING

It can also be part of the investment in art. It is part of investments in art.

Special markets have philately and numismatics.

Medium-low and long-term yields, today they have lost much of their charm.

Collector's watches, on the other hand, maintain a certain public consideration and are able to give economic satisfaction.

At the beginning of the 80s (1980) we like to recall the phenomenon of Swiss Swatch watches that made so much fury in the population and gave a notable contribution to the spread of the collector's mentality.

Today the classic Rolex, Cartier are joined by the Ublot, maybe Ferrari, for 500,000 euros.

For paintings and art objects, the problem always remains where to place them, unless you have beautiful and large houses.

However, more on that later.

ANTIQUES

And a lifestyle choice more than anything else.

Who buys antiques is more for the particular aesthetic sense or for the love of history than for an actual desire for capital gain.

Very difficult to sell immediately and requires a lot of professionalism.

GOLD, SILVER, JEWELS

A safe investment until recently, but now with the extreme difficulty in judging the veracity and certification of precious stones or the volatility of the price that has also affected precious minerals or raw materials of any kind, they make it investment only for experts and a high target.

To hear the professionals, jewelery, for example, is more the emotional, sentimental value that justifies the purchase certainly not its future value.

INTERNET INITIATIVES

Few are those who manage to earn on the internet, many those who waste their time to follow an easy enrichment that does not exist.

Anyone who earns on the internet has nevertheless developed his own work and as such is not part of the investments but of the income, which is not easy, that any job can bring.

INVESTMENT MANAGED

It is theoretically the smartest way to invest your savings whether large or small.

Financial structures made up of graduated professionals with at the head of highly experienced and skilled experts are available, the maximum that can be had to move in the great world savings market.

Considerable capital is required.

It is however subject to the ability and honesty of the team that has to manage the money and the disappointments are there.

BANK - DEPOSIT ACCOUNT

If you want the incredible performance, an ironic comment, of 1.5 or 2% there are time deposits up to 3 years.

We can say that investments are divided by return and risk.

So the returns are

LIQUIDITY low performance

Medium-low OBLIGATIONS

Medium-high REAL ESTATE

HIGH ACTIONS

the risk is classified as follows:

LIQUIDITY low risk

Medium-low OBLIGATIONS

Medium-high REAL ESTATE

Very high-ACTIONS

COMMON INVESTMENT FUNDS

To overcome the investment risk and the immediate scarcity of money have created investment funds.

Mutual funds are financial intermediation institutions whose purpose is to invest the capital raised by savers.

They have entry and management fees

LIFE POLICE

to protect one's life and family from sudden and negative events and can also include a part of the invested capital

But then there is no investment that gives so much?

There are and we can list some of them in the economic history of a nation.

Apart from the danger of heart attacks inherent in all speculative investments we can take into consideration:

RECORD INVESTMENTS.

As the **Monster Beverage Corporetion** the action of the century.

The price has gone from 0.1 dollar to 55

in a nutshell this means that those who had invested just 1,000 dollars 19 years ago today would find in their portfolio about 550 thousand dollars, which exceeded 600 thousand until a few weeks ago .

This is the action that has had the best performance ever, the action to be taken as a stone of comparison for our investments.

Considering that these performances have always had investments in art, in this book I would like to analyze the potential of such an investment.

SECOND CHAPTER

ART

The investment in art is a separate chapter.

A sector that in Italy has its maximum expression in the artists of the past Raffaello, Leonardo da Vinci, Michelangelo or Caravaggio to say a few at random but of enormous importance.

Today throughout the world from Africa to China to the USA there is a continuous and ever-increasing development and understanding of Art in all its infinite facets.

A new vision of the world that only an artist anticipates.

At any level is the investment of the highest cultural and economic value.

All art products have a natural protection from the state, but I would also say from private institutions and people, anywhere in the world.

The soul of a people or a nation is expressed by the art that its citizens create.

This right attitude places investment in art above any other, we recall that the value of Michelangelo's "Pietà" or Leonardo's "last supper" are, at a minimum, equivalent to one tenth of the Italian public debt.

Agriculture is rightly considered the primary sector in the economy, creating wealth practically from scratch, all you need is just a bit of land and seeds.

From this point of view, which is exclusively economic, that is to say, the one that mainly interests us, Art is to be considered "primary sector" since from a canvas or piece of stone a work can be born that, over time, could acquire a value huge, economic, historical, cultural.

There is no such investment in the world.

In the event of a total catastrophe, war, works of art are protected much more and more easily than people.

Let's take Pablo Picasso, a world-famous painter.

With the picture the "Family of acrobats" (family of santimbanques) is today easily salable even for 150 million.

Or the "Boy whit a pipe" framework sold in 2004 for 104 million.

The value of the artist is confirmed in 2010 with the picture "N ***, Green leaves and bust (1932)" sold for around 106 million

Back in 1952, the Sidney and Frances Brody collection had bought the artwork at a *bargain* price of $ 17,000.

Thus 17,000 against 106,000,000 in almost 70, almost doubling in value every year and increasing the value by 6200 times.

But this is not, for now, the aspect I want to emphasize about a work of art.

The company that produces cans with a drink that they like can be worth much.

Its action can have a performance of a few years and in the best case stabilize, then one day discover that the

drink hurts if drunk too much or that another drink is much more good and healthy, an almost certain event.

These facts would cause the value of the production company to fall, which in the case of the **Monster Beverage Corporation** in question has already begun.

It can be said, normality for stock market shares, rise and fall.

For certified and historical works of art this never happens, they always rise.

Another painting by Picasso "Au Lapin Agile" in 1989 worth 41 million.

Apparently, Picasso painted "Au Lapin Agile" in exchange for free meals at a famous cabaret of the same name in Monmartre.

Picasso presented the painting to Frede, the owner of the cabaret.

The cabaret owner sold the Picasso for $ 20 in 1912.

Today easily sold for 100 million, also having a story behind it.

Yes, because this type of investment can also contain a historical value of incalculable value.

This value, even an action of the most important company in the world, will never have it.

"Quernica" what value can it have today?

If there is a defect in these investments it is the difficulty in determining a "terrestrial" value, which a human can understand and accept in his small economic reality, despite being a Gates or an Agnelli.

Apple the famous Cupertino company was valued at 1000 billion dollars.

In just a few years, for the diminished sales of its products, today it is certified on the stock exchange with a value of 756 billion dollars, a decrease of 250 billion dollars.

The Louvre, which has 530,000 works of which only half are considered to be of truly important value, is visited by 8 million people every year.

Its current capitalization can be estimated at at least 250 billion.

Listed on the stock exchange, its capitalization would easily rise to 2,500 billion.

Museums do not enter the stock exchange to avoid the risk of a change of ownership not appreciated by the government or the population.

We are talking about the Vatican Museums where Michelangelo's only Pietà can be estimated at 10 billion and the total value of the Museum, if it could be sold and if there was a person or entity or state that could buy it, it would start from a starting price of 1000 billion .

And from this point of view, the "Italian museum", the only country in the world where people live every day among the works of art, simply walking to work, could be estimated at under 100,000 billion dollars.

It is ridiculous that equally ridiculous institutions put Italy between the "poor" and "bad" because it has a debt of 2% of its patrimonial value.

But let's continue with our works of art and don't go into political and economic speeches that are beyond our task.

We still see some important artists of the past.

LEONARDO DA VINCI

The greatest genius of the 1500s his most famous works are the "Gioconda" and the "Cenacolo".

One of his minor works was sold for half a billion euros.

Value in increment.

MICHELANGELO BUONARROTI

Painter and magnificent sculptor, always competing with the perfection of God, almost achieved with the "Pietà" whose value is priceless.

Placing Michelangelo's "Pietà" on the market is like selling beauty, life and death together, you can't, there is no one who can buy it so much is its value.

Other artists such as Caravaggio, Van Gogh, Goya, Matisse, Monet, Manet have a base value of hundreds of millions.

We have already understood that a work of art, certified as such by galleries and operators in the sector, is a medium and long-term investment of sure aesthetic and economic satisfaction.

Another more complex problem is investing in contemporary art.

Contemporary art has had an explosion of artists and currents that has definitely complicated the work of the art critic and therefore of the evaluation of a work.

Works put up for auction.

We analyze and take into consideration the values of some painters and their increase.

It is logical to think that the works are purchased at a certain price, convinced that it is not the "last price" but a new beginning of a sure revaluation.

Consider the age of birth and especially death to see the economic performance of each artist.

The works of an artist at the beginning are always worth a few thousand euros or dollars and it is the best time to buy.

This is a partial list, perhaps a bit boring but clarifying the value that brings such an important investment as it is always the one in art.

Giorgio Morandi

estimated value 2,100,000

Giorgio Morandi Born in 1890 and died in 1964

440-fold increase

since 1950 considering an initial value of 10,000 million lire, today 2,170.00 euros (ie 4 billion and 400 lire), an increase of 440 times the initial price

We always remember the best performance of the century, **Monster beverage** from 1000 dollars to 550,000, dollars that is 550 times in 20 years, supported by 19% of Coca-Cola shares, but the logic of the stock market says that it will settle down.

Coca-Cola was worth, in 1979, $ 0.83 today $ 48 that is in 40 years has increased by 58 times, still a very good investment.

A picture, not the most important of Morandi, has practically equaled in 70 years in the first case and in the second outclassed and very powerful the company.

It can be said with certainty that the value of the picture will rise and the action with time will come down.

We continue our analysis on painters

Lucio Fontana

our valuation 450,000 to 1,000,000

Born in 1899 in Argentina and died in Varese in 1968

and we always consider as a starting value a 5000 euro, even if the works cost much less, **we have a performance of 93 times minimum**

Fausto Melotti

our valuation at 150,000

Born in 1901, he died in 1806

30-fold increase

Max Bill

our valuation from 125,000 to 350,000

Born in 1908 and died in 1994

25-fold increase

Alighiero Boetti
our valuation at 470,000
Born in 1940, he died in 1994
93-fold increase

Jean-Michel Basquiat
our valuation at 550,000
born in 1960 died in 1988
110-fold increase

Jannis Kounellis
Born in 1936 died in 2017
our valuation at 480,000
i increase **by almost 100 times**

Alberto Burri
born in 1915 died in 1955
our valuation from 270,000 to 2000,000
this has increased **55 times**, others **400 times**

Afro
our valuation at 340,000
Born in 1912, died in 1976
65-fold *increase*

Lucio Fontana
our valuation at 600,000
Increased **120 times**

Giulio Turcato
our valuation at 100,000
Born in 1912 and died in 1955
20-**fold increase**

Piero Manzoni
our valuation at 350,000
born in 1933 and died in 1963
70-fold increase

Alighiero Boetti
our valuation at 309,000
60-fold increase

Mario Schifano
our valuation from 125,000 to 300,000
born in 1934 died in 1998
2 **5-fold increase**

Michelangelo Pistoletto

our valuation at 500,000

born in 1933 The only child of Livia Fila (1896-1971) and the painter Ettore Olivero Pistoletto (1898-1984)

I increase **by 75 times**

Alex Katz

HARBOR 10

our valuation at 300,000

Born in 1927 - Living

50-fold increase

It is a market, roughly, equivalent to the real estate market for figures and quantities, among the most varied.

The difference is that in 50 years the houses will no longer exist, while these works of art will be worth twice as much and will embellish and make other houses precious.

THIRD CHAPTER

WHO WILL BUY THE WORKS OF ART?

Statistics show that he lives in the North (77%), is about 60 years old (43%), loves painting compared to other artistic expressions (32%), buys about 5 works a year (71%) and he does it mainly through passion (61%), particularly in galleries and dedicated fairs.

It is the profile of the Italian modern and contemporary art collector.

More than 200 collectors have participated in the first survey on a reality still little analyzed in Italy, which aims to photograph the state of the art of Italian collecting, which finds its stronghold in the North.

NUMBERS OF ITALIAN ART COLLECTIONS:

It seems that 77% of Italian collectors reside in the regions of Northern Italy and are 60 or older.

Italian collectors visit the fairs and buy mainly in classic way from art galleries, to auctions or at dedicated fairs.

Fairs, auctions and the Web are the channels that most influence them in their choices.

Italian collectors buy on average about 5 works a year.

About **10,000 contemporary art collectors are** currently active in the world.

And Europe, in this particular sector of human activities, holds the record, "hosting" **40% of contemporary art collectors in the world.**

Followed by North America (30%) and Asia (20%).

As we understand from a first glance the data just reported that everyone knows, give us an inevitably partial view of a global phenomenon that is certainly larger.

It can be assumed that in Italy about 3% of contemporary art collectors reside, a value destined to diminish given the increase on the scene of Chinese and African collectors

Among these collectors, known by all the operators in the sector, the names that annually are included in the rankings dedicated to

Top Collectors:

Patrizia Sandretto Re Rebaudengo,
The couple Miuccia Prada and Patrizio Bertelli,
Valeria Napoleone,
The Maramotti Family or Ginevra Elkann .

Just to name a few.

To these 150, we should add at least another 150, thus totaling about 300 as regards Italian contemporary art collectors in possession of important collections.

It is a reality still little known, if not through the individual experiences of collectors who have moved from the private dimension to the public one.

But here are some of the most important collectors in the world:

Eli & Edy the Broad

Eli Broad, born in 1933, an American entrepreneur, one of the richest men in the world,

Maja Hoffmann

The founder of LUMA, Switzerland, born in 1956, the collector,

LUMA Foundation, is a non-profit organization founded in 2004, which supports the activities of independent contemporary artists

Bernard Arnault

He is one of the most powerful collectors in the world, but also one of the richest and most influential men on the planet.

Head of the LVMH group, which controls brands such as Bulgari, Fendi and of course Louis Vuitton, Arnault

Patricia Phelps de Cisneros

The most influential collector in the world is Venezuelan.

His collection of Latin American art is one of the most important on the planet.

The Japanese Yusaku Maezawa

became famous for having purchased a work by Basquiat for the record price of 110.5 million dollars (12.5 million commission only at Sothebyìs.)

But there is the world of finance behind the big investments in art: 40% of the great collectors are men of finance, followed at a distance by real estate developers with 17% and by fashion entrepreneurs, demonstrating that the money earned "dangerously" in a bag or with a normal job they must be consolidated and secured by buying Art, the one with a capital letter.

This certifies that buying art, classic or contemporary, is the only real investment in security, even if a good part of the property developers makes use of it.

FOURTH CHAPTER

FIRST RULE
How to buy a work of art.

We have seen that investment in art is the best thing you can do to secure your money.

But to invest you have to buy.

It should be a practice to be implemented whenever you buy an apartment or villa.

At least 10% of the value of the home should be dedicated to an art purchase that makes the home valuable and valuable. Any home.

When you finish paying the mortgage on the house the purchase value of the work will probably equal the value of the home.

The same when a child is born.

It would be nice to plant a tree and buy a work of art.

Link the growth of the tree, meaning of nature, and the perpetuation of art, meaning beauty and elevation, to future generations. It could be the best way to value a birth.

Instead today we see many houses all over the world without a work of art that can make it special.

From the economic point of view, in any case, we can say that we have demonstrated the superiority of

investment in Art over any other, both for the certainty of performance and for the still enormous reservoir available, that is the quantity of works produced by a more and more artists.

This available quantity does not imply inflation, because it is opposed by a strong increase in the population.

Art as a necessary product for the quality life of all the people of the world.

Art as the hope of a life choice that every person should undertake, abandoning the path of hatred and war.

Even Tolstoy in considering the beautiful, the useful, the taste, the truth, in his essay "What is art" comes to a similar conclusion.

For Tolstoy, true art is that which propagates, capable of arousing in man feelings of joy in spiritual communion with the artist or with others who contemplate it.

Art can stimulate peaceful coexistence among men.

The authentic art, for Tolstoy, is therefore «popular art and not a collection of works.

The necessary sentimental consequence of every authentic wisdom of life.

We talk about it in this book we introduce ourselves, and with us our patient reader, into a whole new world, very different from that of everyday life made up of repetitive acts, superior orders to be performed, rules imposed by others, bureaucratic obligations completely extraneous to human feelings .

Just talking about art puts us on a level of beauty, satisfaction and harmony with others that can only make us happy.

We return to the "first rule" of "buying a work of art" we must be convinced of: "why" buy a work of art?

It is clear to everyone why to buy a refrigerator.

The primary need to be able to preserve food for so long, so precious, always expensive, since the birth of life on Earth.

It all comes down to the need to have, buy or rent a home, our personal and family world.

A world where we guard our "riches", first and foremost our wife or husband, our children, our parents, any person dear to us, but also our friends, the dogs and cats, who are increasingly indispensable.

In this place we collect all that can make our life fuller and more satisfying.

We buy appliances, refrigerators, dishwashers, washing machines, showers, televisions and so on, including the car to which we dedicate a personal house.
The quality of life increases with the possession of a library, albeit small, and various audio or video recording media.

Our quality of life increases with the satisfaction of our knowledge.

With books and the internet we have been able to bring myriads of concepts within our reach, in all fields of knowledge.

From health, to vacation spots. We have known animals that we will never see or very distant and beautiful places that we will never visit.

This is why the next step, which many have already done and which in the past was only available to the rulers and the powerful, is to have one or more works of art in our home.

With progress, all that was once only available to kings, politicians or big industrial magnates is now being made available to an ever greater number of people.

This is a huge step in the evolution of the people.

A step that should finally determine the spread of a higher capacity to discern the good in human action.

The progress of humanity will point to man's progress, to his search for his intellectual potential, to his differentiations seen as wealth.

To buy a work of art we must distinguish the emotion and the thought that an art object procures.

There are those who say that a work of art is such if it produces emotions, others if it produces thought.

But we hear several quotes:

" *Natures like yours, with strong and delicate senses, the inspired, the dreamers, the poets, the lovers are almost always superior to us men of thought.*

Your origin is maternal.

You live in fullness, you are given the strength of love and living experience.

We spirituals, who although we often seem to guide and direct you, do not live in fullness, we live in dryness.

To you belongs the riches of life, to you the juice of fruits, to you the garden of love, the beautiful country of art.

Your homeland is the earth, ours is the idea.

Your danger is to drown in the world of the senses, ours is to asphyxiate in the void.

You are an artist, I a thinker.

You sleep in the mother's chest, I watch in the desert.

The sun is shining on me, to you the moon and the stars ..."

Hermann Hesse

" Painting is stronger than me; it forces me to paint as she wants "said Pablo Picasso

" The works, as in the artesian wells, rise higher the deeper the suffering has dug the heart." Marcel Proust

Synthesizes Henstein "Art is the expression of the most profound thought in the simplest way.

"I am forced to continue transformations, because everything grows and revives.

In short, by dint of transformations, I follow nature without being able to grasp it, and then this river that descends, rises again, a green day, then yellow, dry afternoon this afternoon

and tomorrow it will be a torrent. "Cloude Monet

The importance of art is thus summarized by Lev Tolstoy:

"Art is a human activity whose purpose is the transmission of the most elected and the best feelings"

And Oscar Wilde tells us what we are looking for in art. "What art tries to destroy is the monotony of the type, the slavery of fashion, the tyranny of habits, and the lowering of man to the level of the machine."

Here is the thought of famous writers on art:

If the world were clear, art would not exist. Albert Camus

To the question: - What is art? - You could answer by concealing (but it wouldn't be a silly joke): that art is what everyone knows what it is.
Benedetto Croce

If there is something on earth and among all nothingness to worship, if there is something holy, pure, sublime, something that satisfies this boundless desire for the infinite and the vague that they call the soul, this is art. Gustave Flaubert

There is no safer way to escape from the world than art;but there is no safer bond with

it that art.Johann Wolfgang Goethe

The artistic experience is so incredibly close to the sexual one, to its pains and its pleasures, that the two phenomena are in reality only different forms of an identical yearning and bliss. *Rainer Maria Rilke*

The difference between art and life is that art is more bearable. Charles Bukowski.

FIFTH CHAPTER

INVESTING IN ART

Investing in art is not simply buying what you like.

To invest in art, some things must be kept in mind.

Its value must not be combined with the emotion that can derive from it

Avoid making the most common mistake "confuse the value of a work with the emotion it gives rise to in you" especially when analyzing a contemporary work.

Consider the artist who is often the protagonist of the diatribe "it *is art - it is not art*", that is Lucio Fontana.

Fierce criticism for the enormous, and for many inconceivable, quotations that his works reach.

The accusation most used by his detractors, in addition to the classic "*I could do it myself*", is precisely: "*It is not art because it does not excite me*".

Thinking in this way, you enter a blind alley.

Emotion is something extremely personal and how do you enact the status of a work of art

Thought is the unique feature and above the parts that can lead to the evaluation of a work of art.

And for many critics the purpose of a work of art is to make us think, the emotion is a consequence.

Many artists, like the Impressionists, excite.

Many hyper-realists get excited when they paint a crying baby, for example, but what sets him apart from an equally good craftsman in creating such a painting?

It is not the emotion that the technique that can decree who is an artist and who is not, what is art and what is not.

Art is the creative process that is the fruit of human love and that contributes to the intellectual growth of all men.

Artists like Andy Warhol have focused their entire career on this operation of the ordinary in art.

The work takes a back seat, because the gesture, the criticism, the artist and the market matter the most.

What counts more is the discussion that involves the work, therefore the thought that springs from the work.

So when we have this in mind, we can introduce ourselves into the art world.

For example, according to many, **advertising is emotional, art must make people think.**

Clearly there is the capacity to reason about the meaning of a work of art it is easier to invest and this is true in all fields of the economy.

The investment is different from simply owning a work of art, a choice that can only involve the emotional part of us.

At this point I would add a third requirement to be able to choose a work of art.

It must be a reason for novelty in what the artist proposes to us.

I'm not saying it's a new artistic current, but what can amaze us.

SIXTH CHAPTER

WAYS TO INVEST OR SELL IN ART

In recent years, the turnover of investment in art has doubled worldwide, rising from € 35.9 billion in 2005 to € 90 billion.

Making investments in **art** is becoming a trend within the reach of all business.

The primary art market

Buy directly from the artist.

Here you do the real business, you can buy works of art from the artists, it can be a unique experience and also a way to invest in truly valid art.

We remember the story of **Antonio Ligabue** , who in his time was more tolerant than ever, he is a madman who has sold his works for a dish of lentils, or for a package of his beloved cigars or for a few pennies, works that over time they have acquired enormous value.

RAI also broadcasts a fiction of considerable interest.

This does not mean looking for the unwary artist to cheat or exploit him, perhaps taking advantage of temporary periods of need.

Then we see many customers.

Come in the times of the Renaissance when the cardinals order themes on which the artists look at each other and think about their own skills.

I accept orders from clients does not invalidate the artistic ability or of the woman artist who can always free her creativity in other personal works, but rather can free it from those constraints of daily economic necessity that many times conditions its line in a coercive way.

The secondary art market

Investing in art in the secondary market, these are second-hand works, we talk about **secondario markets:** gallerie d'arte, case d'asta e mercanti d'arte.

This is the market with which it is necessary to confront oneself in order to enter the magical world of the art market, only by visiting art galleries can one begin to have a perception, know, artists and their stories, develop an eye that manages to give a monetary value to a work of art.

We will explain later that you can start even without risking money and have all the time to enter the art world even without knowing artists or gallery owners.

Only in a second time and only after understanding and basing the foundations of the history of art and the history of contemporary art and its current being can be compared with experts and "smart" art dealers and art dealers.

SEVENTH CHAPTER

AUCTIONS

They are part of the secondary market. For those on a budget, it's sure it's safer, safer to buy.

Just choose the most certified one that will certainly present the best deals.

CRISTIES'S

Londoner, among the oldest auction houses in the world. Information on the calendar, catalogs, collectors, galleries and museums.

There is the possibility of attending auctions live thanks to an online video streaming service

SOTHEBY'S

The oldest house scattered around the world, offers the opportunity to participate in auctions through their own web pages.

We have seen you, we have listed a number of Sotheby's to better understand how it works and the potential of the market.

HIP

National Auction House Association where you can find information and information on the well-known Italian Auction Houses: calendar of events and description of the information in the program

BONHAMS

One of the most important private auction houses dedicated to art and antiques based in London.

FARSTTI

In the official site the history of this house and also gallery active since 1955 with all the addresses and information to consult. Auction results, archives and registration are online

ART AND BUSINESS

Telematic broker in the field of contemporary figurative arts proposed on the market by gallery owners and collectors.

ARS VALUE

The successful auctions in Italy and in the world, with pieces of modern and ancient art including paintings and sculptures. Directions on how to participate in live auctions

Artistic price

World leader to know the prices of the many Italian and foreign artists, to access the site registration is required

Babuino Auctions

Famous auction house in the center of Rome for lovers of collecting in general and antiques. You can book for the phone call

Poleschi

The protagonists of the auctions organized by this Milanese gallery postpone important names in the national and international panorama of modern and

contemporary art. Information and dates directly on the official website

STUDIO D'ARTE BORROMEO

An agile and lean structure thanks to a young team.

BASEZERO AUCTION HOUSE

FINARTE

At the end of 2014, a group of new investors acquired the **Finarte** marca.

A company of collectors for collectors .

Phillips

Phillips is among the most important houses in the world. Focusing in particular on the art of the 20th and 21st centuries, Phillips stood out for its dynamism and foresight. Headquartered in New York and London and with offices around the world,

The Dorotheum - from 1707

Europe's largest auction house.

EIGHTH CHAPTER

GALLERIES

Even the art galleries are part of the secondary market but many also on the primary market.

The most famous are now considered and considered their market operating in close symbiosis with the most famous art fairs and controlling the most famous artists of the moment.

Purchase certainty, price control is a defense of the gallery and the artist, with unique proposals addressed to an elite of collectors and old customers.

The criticism is of having built a window, where new young collectors are going to find it very difficult to enter.

These are some galleries in Europe ::

Austria:

Galerie Krinzinger (Vienna)

Galerie Thaddaeus Ropac (Salzburg / Paris)

Belgium:

MOT International (Brussels),

Xavier Hufkens (Brussels)

Zeno X Gallery (Antwerp)

Denmark:

V1 Gallery (Copenhagen)

Finland:
Galerie Forsblom (Helsinki)

France:
Art concept
Galerie Chantal Crousel
Galerie Perrotin
Galerie Kamel Mennour,
Praz-Delavallade (Paris)

Germany:
Blain | Southern (Berlin / London),
Galerie Buchholz (Cologne / Berlin / New York),
Esther Schipper / Johnen Galerie (Berlin),
Galerie Hans Mayer (Düsseldorf),
König Galerie (Berlin),
Galerie Karsten Greve (Cologne),

Greece:
The breeder (Athens)

Iceland:
I8 Gallery (Reykjavík)

Ireland:
Kerlin Gallery (Dublin)

Italy:
Galleria Franco Noero (Turin),

Frutta (Rome),
Kaufmann Repetto (Milan),
Lia Rumma Gallery (Milan / Naples),
Galleria Massimo De Carlo (Milan)
Holland:
LionelGallery (Amsterdam)
Norway:
Standard gallery (Oslo)
Portugal:
Galería Filomena Soares (Lisbon)
Czech Republic:
Hunt Kastner Works of art (Prague)
Romania:
Ivan Gallery (Bucharest)
Spain:
Galería Elba Benitez,
Galería Elvira González,
Helga de Alvear (Madrid),
Espaivisor Gallery (Valencia)
Sweden:
Wetterling Gallery (Stockholm)
Switzerland:
Galerie Bruno Bischofberger AG,
Hauser & Wirth (Zurich),

Galerie Urs Meile (Lucerne)

Turkey:
Rampa, Rodeo Gallery (Istanbul)

UK:
Bernard Jacobson Gallery,
Lisson Gallery,
Simon Lee,
Timothy Taylor,
Victoria Miro Gallery,
White Cube (London)

Hungary:
Kálmán Makláry Fine Arts (Budapest)

Galleries operated by women

Particular attention should be paid to the Gallery managed by women because they have a particular evident artistic quality sensitivity.

Here are some:
Vanessa Carlos
Carlos / Ishikawa Gallery London
Almine Rech

Almine Rech Gallery Paris, London, Brussels, New York

Hyun-Sook Lee

Kukje Gallery, Seoul.

Esther Schipper

Esther Schipper Gallery, Berlin.

Luisa Strina

Galeria Luisa Strina, San Paolo

The art galleries are and will be, for a long time to come, the central point of reference for the neophyte collector or the classic collector or the art lover who wishes to purchase works.

We need to visit galleries and art fairs and talk to industry professionals and start to understand how the current art system works.

As we have seen, the galleries operate on both the primary and secondary markets. Many times the galleries "kidnap" the sponsored artist by buying the exclusive sale, maximizing the sales value of the work of art and lowering the outlay to the artist who has a guarantee in this way of a certain entry ..

To understand the galleries you have to divide them into two groups

The first is the economic one, ie high, high, medium and low band.

The second is the geographical one, that is if the international, national or local market.

NINTH CHAPTER

CRITICS OF ART - OPINION LEADER AND DEDICATED WEBSITES

In the art world I also live and prosper art critics, opinion leaders without forgetting the managers of the websites that they do but do not explain the importance of being in everyday life even for simple people.

Art critics are so good at spreading the artistic word in the people of the people that, for example, the Italian government has decided to abolish the study of Fine Arts.

It is clear that the people responsible for the defense and development of creativity and beauty in the world have lost the battle against fiction, talk shows and various TV series where there is everything but not art or quality literary text.

It seems, and perhaps it is true, that many art operators, including artists, think a distant money at the expense of knowledge and the spread of an artistic culture.

However, read the books of the various art critics in the world.

Then there are the art curators powerful professional art operators.

Here is a small list for you

Born Thompson

Famous for his "Pop-up" projects in Philadelphia (Pennsylvania),

Sheikha Hoor Al-Qasimi

daughter of Sultan Bin Al-Qasimi, current Emir of Sharjah, one of the 7 United Arab Emirates. Always a great art lover, through her Sharjah Art foundation she manages huge amounts of capital.

Christine Macel

Chief Curator of the Pompidout Center since 2000

Massimiliano Gioni

Our compatriot Massimiliano Gioni (Busto Arsizio, 1973), remains one of the great boast of Italian culture and art abroad.

Director of the Trussardi Foundation,

Adam Szymczyk

Adam Szymczyk remains the most influential curator in circulation now for a piece br or

Then in recent years many online art galleries have been created on the internet selling and buying or selling our little studioartgallery.it

Below is a small reminder to simplify your visit and take a tour of art and meet new artists.

WEBSITES DEDICATED TO PURCHASE OR SALE

ARSVALUE.COM ARTANTIDE.COM ARTFACTS.NET

ARTINFO.COM ARTNET.COM ARTPRICE.COM

ARTTACTIC.COM ETSY.COM

BARNEBYS.COM

There are more operators who gravitate around the real or at least those who should be the only real protagonists of the art, the artists, than the artists themselves.

In this true chaos, those who go there are all art lovers who must succeed in finding their own line of conduct if they want to enter the magnificent artistic world.

it is therefore important to ask the question:

"How to distinguish a work of art and a true artist?"

Art begins with the life of man on Earth and ends with its disappearance.

There are no rules for judging or producing Art.

Be happy with the large amount of visual art that continues to increase and move from our visuals of life.

The first reason that drives visual art is Emotion.

Some say that the work of art is that thing that keeps you glued to looking at it, without feeling the need to leave.

The "Stendhal Syndrome" is legendary.

Thus states the definition: ".. is a psychosomatic affection that causes tachycardia, dizziness, vertigo, confusion and hallucinations in subjects placed in the presence of works of art of extraordinary beauty, stories if they are compressed in limited spaces ".

One divulge was Graziella Margherini, head of the mental health service at the Santa Maria Nuova Hospital in Florence

The doctor wrote in 1979 " *Stendhal's syndrome. The malaise of the traveler facing the greatness of art* ".

The inhabitants of the Uffizi rediscovered in front of a hospital near Florence.

To choose a work of art you certainly don't need to lose your head, but a strong emotion, a transport, a feeling yes.

You should not buy art objects for mere speculation.

Very profound motivations, which affect or concern our subconscious mind, our conception of beauty from the memories of our life, you think in the choice.

But the second is an artist who produces art is Thought

If the work of art is capable, in addition to emotion, even the possibility of reasoning about what the artist really intends to communicate with that object or gesture or artistic product, we can tell ourselves certain to be in front of art and therefore to a true artist.

It is the problem of contemporary art and of many artists completely opposed by public opinion.

Many contemporary works emotions, many times negative, in the people who look, but it is only thought, reasoning, trying to understand the artist, feeling his life motivations.

When we are faced with an object that produces emotions, positive or negative, and at the same time forces us to use the thought to look for the truth of what the artist wants to say, a search that is nothing else a search in ourselves.

Only then can we say with certainty that we are facing a work of art.

TENTH CHAPTER

COMPANY FEE ON STOCK EXCHANGE

Art has enjoyed a good recovery in a year, helped by strong Asian demand and an increase in the rich of the earth (HNWI 10.9 million in 2010), despite the crisis.

Art is considered a real asset for covering financial markets, we are talking about historicized works, but also about new emerging artists.

In recent years the market has been transformed by increasing its geographical area, registering the entry of the usual, inevitable speculators, and widening its offer structures, from the multiplication of fairs and auction houses to the explosion of charms online.

The growth of the sector attracts the attention of investors all over the world

The art, it is clear, must be detected as a safe haven where to deposit any profits.
Financial advisors are still skeptical about their clients' investments in art for these reasons:

lack of market transparency.

the absence of institutional interest in investment in art

reduced liquidity,

the non-existent risk assessment standards

the lack of shared industry benchmarks

the need for independent due diligence

and few track records of the funds,

all the aspects that make it difficult for wealth managers

These judgments were then denied by the exponential increase in private investors, in Asia, Latin America and even in Africa.

However, there has been an exponential increase in loans for artistic acquisitions, a clear demonstration that the profit obtained is significantly higher than the interest paid.

China already has about thirty bags dedicated to art and not by chance is the explosion of Asian artists both in numerical and qualitative and economic terms.

France had launched one.

Then there is the stock exchange open in Luxembourg, its name is **SplitArtTM** and it is in a financial trading system that allows qualified investors to acquire shares related to works of great value.

Actions of works of art?

Certificates" are used, which can be purchased as shares of any company listed on the stock exchange, offering the opportunity to share the artistic good with those who cannot acquire a whole.

We of studioartgallery.it will propose something similar without all the bureaucracy that undermines many times the performances and without the interference of third parties that do not guarantee security and transparency at all.

While these issued certificates can be purchased and sold only through recognized market members, such as banks and financial institutions that will do nothing but increase costs and slow down the purchase or sale.

Once purchased, the certificate can be offered for sale at the buyer's discretion, just as it works with stocks.

If a buyer is able to buy 100% of the certificates of a work, he can get physical possession of the object, while if he reaches 80% he can force the others to sell him the remaining shares, but so they are subject to the blackmail of whom have 20% that will raise or lower its value exponentially, making the sale or purchase not convenient.

While, we will see, our system is much simpler and more reliable than avoiding speculation on the work of art, being direct.

Let's go back to the bags in a way that is much more open, maybe even too general.

That is the difference with the stock market: only the galleries can sell, and are still on the list, they can still be to the public or they can sell to the stock exchange, but in this case they will lend themselves a museum.

The Paris Bourse also had to open a gallery itself ..

It's definitely a new way to make a work liquid that you want to free.

But what are the buyers?

What is the taste of owning a piece of a work that could never be enjoyed up close?

Certainly it is not from art collectors, in the true sense of the word, but from investors eager to invent a new market to diversify their savings.

Thus a new figure of collector is emerging, a sub-category that represents the natural evolution of the "*specullector*", a figure that is getting closer and closer to that of the financial investor.

The fact remains that it is no more profitable than a work of art of its spiritual, emotional and thinking essence, an infinite paradox.

ELEVENTH CHAPTER

SECOND RULE
understand what you like

We buy what we like, what excites us and what makes us think.

Anyway, visual art, painting or sculpture must fill us with emotion.

It must be an object that stays in our house every day, that must give us intense emotions, remember events of history or our own.

An object to show happy to our friends.

Nothing better than sharing our best experiences with friends, relatives or strangers, invited to participate in our joy.

Yes, a work of art must be shown as much as possible by an increasing number of people.

I consider a disaster like that which happens in the big or small museums that are, where works by authors are Monet closes in private or public deposits, created for:

A work of art must be admired.

A work of art communicates a message, it can be historical, that is to say, an important event remembered in history books that changed the course of life of a nation or an important family.

Or a visual prayer with the numerous religious representations.

Like the famous "Madonnina", also known as La Madonna del Riposo or La Madonna delle Vie, it is a painting on wood by Roberto Ferruzzi from 1897.

How not to remember the immense masterpiece of Michelangelo's "Pietà", for us the artist of artists in constant competition with God (nature) to know who is the best.

Or a daily event like "La Lavandaia" by Honoré Daumier from 1863 and exhibited at the Musée d'Orsay in Paris.

Everyday memories include "Milkmaid"

The Milkmaid is an oil painting on canvas by Jan Vermeer, dating from around 1658-1660 and kept in the Rijksmuseum in Amsterdam

Everyday depictions and genre painting also The Night Watch and The Anatomy Lesson by Dr. Tulp by Rembrandt (1606-1669).

They are a bit richer memories of life lived, small episodes or great historical events.

Even in the memories of love and admiration the painting by Leonardo da Vinci "La Gioconda" for which millions of people go every year to Paris to admire in the famous Louvre museum.

I conclude with an artistic provocation, in line with the provocative performances of modern contemporary art.

The painting "La Gioconda" by Leonardo da Vinci has had millions of years by artists from all over the world and therefore, last of the last, we publish on the website studioartgallery.it the photo printed on canvas, not by chance called "la Monna Elisa", by Marco Barzaghi, as an emotional picture and as a thinking provocation.

His look like that of Leonardo's Gioconda is inscrutable and magnificent at the same time.

Created, as the Mona Lisa was created, to remember an important moment in the life of the great artist.

Yes art approaches the great, infinite genius of Leonardo to the small, almost non-existent genius of the neophyte artist.

The infinitely large touches the infinitely small through the beauty and the inscrutability of the models' smile.

This is a priceless miracle, within everyone's reach and transcends mere interest, encroaching into physics and mathematics, bringing a picture into the poetry of "I illuminate myself with immense" the smallest poem ever written and at a tragic moment on the war front. Short poetry but of infinite meaning.

Do you come to value what we like? It is an infinite value.

TWELFTH CHAPTER
THIRD RULE
buy young contemporary artists

In order to choose an artist and his work, you need to know the artist and his intention to create.

Young artists or semi-unknown artists with an evident artistic personality can be ideal to start.

For those who cannot, for economic reasons, buy a work of art, we recommend following this reading.

We will take you step by step to understand how you get started in the art world and immediately get good earnings.

In any case, one must inquire, study the history of art in order to have the minimum basis for moving.

It helps a lot if you are happy to learn the history of artistic periods, the life of past and present artists, maybe visit them in their stores. Get to know them in various exhibitions in galleries or art fairs.

With our method, it is always the thought of starting a story that led to an artist or artistic current, in a historical work of cultural importance.

Another question follows

Which artist to invest in?

As will be clear, we certainly cannot think that a small saver with a capital of 50, 10 or even 200 thousand euros can invest, can invest in classic painters of international renown. Let us therefore forget both the

Caravaggio and the Van Gogh, but also the modern Picasso, Dalì ', Warhol.

However, there are many contemporary Italian and foreign artists who are very valid whose paintings can be brought home even with a few hundred euros.

A canvas that today you can pay 5,000 euros could be worth 20,000 in 10 or 20 years, if you can find the right artist and this type of income is only possible with art, no other type of investment can be so profitable.

A castle can be worth 10 million but in the same castle there can be 1000 million of artistic value in paintings and sculptures.

You can pay a good bricklayer who builds your house but only an artist makes it "YOUR HOME"

An artist must satisfy the two rules of Emotion and Thought I would like to add something new.

We have already said the two rules that it is always better to repeat: EMOTION - THOUGHT, but I would add without a shadow of a doubt NEWS, perhaps a new artistic trend.

C che il Van Gogh, ma anche il moderno Picasso, Dalì ', Warhol.

Yes, because Art is also the research, development and progress of the mind that is reflected in an artistic work created with new techniques and materials that, shaped by the true artist, can reflect the essence of the moment in which we live or liveLook for the artist who can take you on a fantastic journey, ugly or beautiful as it may be, which combines your mind with the emotions Amare makes.

THIRTEENTH CHAPTER

FOURTH RULE
find young artists of a new artistic line

As mentioned in the previous chapter it seems easy, but if this new line does not exist because there is no artist up to the task, we cannot invent it.

We must arm ourselves with patience, read art newspapers and magazines, visit museums and support fairs and galleries.

Surfing the internet where many artists are independent, in order to avoid any speculative contamination or psychological conditioning that becomes deviant from their artistic intentions.

We repeat therefore in underlining the rules, that along the reading of this book have now become three:

EMOTION

THOUGHT

ANNOUNCEMENTS

But do art professionals do an evaluation of the work to buy?

The question therefore to ask is:

Come and evaluate a Work of Art:

Here, the others are standard, but it didn't come in the other types of investment, for example **gold** , where there is the percentage of gold of an ingot, or for diamonds, where I carat, purity, cut and other factors are a success, the same diamond all over the world, with very small fluctuations; in the art market this is not the case.

Here we must rely on judgments of <u>art experts Rics</u> (The Royal Institution of Chartered Surveyors), which way of their rules come from independence, objectivity, uniformity in evaluations, but combined with truth?

If I take 2 Rics experts and have them evaluate the exact same picture, will they give me the same assessment?

Obviously not, because then there is the human element that makes the difference, maybe they will give two precise similar ones, but it is almost impossible to give identical evaluations.

Another method of evaluation can be insurance.

To take out **insurance against theft** of a painting, before paying the insurance premium I need to know how much the work is worth.

There can also be an estimate for a **financial guarantee.**

Tax assessment of a work of art is different from the evaluation

1. In the United States, the valuation for insurance purposes is usually higher than the tax one, in that in the event of damage or theft, the insurance reimbursement must be sufficient to purchase another identical work or anyway of equal value, ie work of art that is of the same type and of the same quality.

2. Fair market value, on the other hand, is also used for tax purposes. This will serve in case of sale of the work, even if it may change over time, due to the will of the same seller at the time he sells it.

3. Finally, there is a fair value, and it is the value of a work of art when the owners are two spouses who must share them in the event of a divorce.

4. Liquidation value or bankruptcy, activated when there is no time to sell.

5. Save value, which is the residual value after a job has been damaged.

Factors that determine the price of a work of art:

1. The artist's name and its importance.

2. If the work is true, or we are facing a forgery.

3. If the work has been published in general or international catalogs.

4. Origin of work

5. Job exposure curriculum.

6. When it was made by the artist

7. If the artist has produced so much or a little.

8. Size of the work.

9. Whether the artist is known around the world or not.

10. Technique used

How the work is preserved - state of conservation of work.

Place of sale

Obviously each factor is very important and has its variables, but these are the main things to look for when determining a price.

How to protect yourself from indifferent purchases, ie how to invest in art but not to buy a counterfeit work of art:

1. A work of art must have certificates of origin and certificates of authenticity.

2. When you buy, we ask you for a receipt or an invoice with a job description.

3. Verify the certificate of authenticity with the artist who performed the work or the person authorized to archive the work.

4. Check if the original work and the authenticated photo are the same.

5. It is preferable to rely on foundations, experts with academic qualifications and archives

6. Before buying, you must discover both the work and the artist.

7. You need to know the market and prices before improvising art investors.

8. Make use of proven auction houses.

Buying directly from the artist eliminates many steps and makes it easier to buy

Investing in modern art to leave a legacy to posterity:

Investing money in works of art does not only mean waiting for years to know that work has doubled or increased in value, it also means thinking about the future of offspring and their good name.

Today as today these are values that are lost, but we think of one of the most famous collections in the world and that we all know because in Italy: the Medici collection in Florence.

The most prestigious families have always left priceless works of art to their heirs, who have become real symbols of cities or even of nations, think that with only one painting, after 2 centuries an entire family can be economically settled throughout the life.

Having a room where you can collect a small collection of works of art is fortunate that not all families can afford it, but it is a type of investment that everyone who can afford it should do, in the name of art and prestige of own

FOURTEENTH CHAPTER

FIFTH RULE

new ways to invest in art

Before presenting the new method of investing in the art of studioartgallery.it make a small forecast on a website that says:

" Investing money in works of art does not just mean that you have a tenfold value, it also means the future of the progeny and your good name.

Today you come today in values as you are losing, but we think of one of the most famous in the world and that we all know because in Italy: the **Medici collection** in Florence.

The most prestigious families have always left priceless works of art to their heirs, who have become true symbols of the cities or even of nations, think that with just one framework, after two centuries an entire family can be permanently established throughout the life.

Having a room where it is possible to collect a small collection of works of art is fortunate that not all families can afford it, but it is a type of investment that anyone can afford it should do, in the name of art and its prestige.

In this book we propose our idea realized by studioartgallery.it, for all those who cannot commit the capital and wait years to get the desired fruits.

The Studio art gallery offers its bonuses and we'll see their usefulness later.

For now let's see how to invest in art.

There are only 10,000 collectors in the world and about a million artists, clearly improvised statistics, but by deduction, quite close to the truth.

So those who buy Arte is only one in 750,000.

It can easily be said that if you pass only 2 out of 750,000 the value of those who already own a work of art would multiply the purchase value geometrically by 4 times.

We now know that we need extra money available for any investment.

Those who buy art know that it is a medium, long or long term investment.

It is made to bequeath a certain capital and a certain way of living and understanding life.

For this reason we do not propose to buy, with a minimum expense, I have BONUS of studioartgallery.it, site dedicated to the promotion of contemporary artists, Italians and of whom their biography and their way of seeing art are studied.

With this way we will try to bypass the problems of investing in art:

The necessary capital.

The long wait for a possible profitable sale, being a long-term investment.

The difficulty of determining the right purchase beyond the emotion exercised by the work on us

The difficulty of ascertaining the authenticity of the work to be purchased

The place to exhibit or deposit the purchased work, which may be large.

Visits to distant fairs and galleries to reach for the work

Bureaucracy, at least in Italy, which wraps art.

But what are the artists who bought studioartgallery.it?

They are works that satisfy in full or in part the conditions of EMOTION AND THOUGHT

These are some ARTISTS suggested by studioartgallery.it

CARAFI ISABELLA

Isabel Carafi divides her existence between the South American, American and Eurasian continents, she was born in Buenos Aires, Diploma National Academy of Fine Arts of Buenos Aires 1978, she moved to Italy in 1980

He graduated from the Carrara Academy in 1984

He lives in Carrara from 1979 to 1991, since 1999 he lives in Trieste.

The traits of his pictorial poetics are unmistakable: not pure representation, not mere abstraction but almost anthropological research.

The subjects of his works mix the semiotic value of caricature, the taste for naive design, with contemporary architecture, the various various techniques and materials

from sculpture, painting, installations, photography, digitalart.

CHIAZZOLLA DANIELA

Biography

Born in Melfi (PZ), she graduated from the Art School and refined her technical skills,

attending individual courses in various painters' workshops, thus learning the art of making art ".

He has participated in various exhibitions and biennials in Italy and abroad.

The technique of his creations varies from oil to pastel to sculpture, but first and unchanging among all loves is that of graphite ... a simple but versatile, elegant, refined material ... that the artist uses as a source for his passion for the portrait and the human figure.

Artistic philosophy

The philosophy of his paintings is nourished by his personal and inner growth ... a continuous discovery, seeing and loving each other as a creature loved and desired by a larger and more perfect Artist ...

Art, in fact, seen as a pure source of beauty, is the admiration of creation that we see, producing Art, thus the artist becomes a co-creator, giving life to works that will remain changeable over time. therefore, it is connected to the spiritual path of the artist, becoming inspiration, sensation and finally a work.

CIUCIU ALINA

Painter of feelings, Alina Ciuciu lets her fantasy gallop and here they take photos with unique shapes and colors.

Each painting, each canvas, has its own precise and defined history.

One of his reasons that proves live Alina Ciuciu, who puts every time a piece of herself in every work.

A memory, an emotion, a place, an escape into fantastic worlds

Animals are a subject that often appears on Alina Ciuciu's canvases, roosters, crows, cats, fish, lions and a whole Ark of colors and expressions.

Almost unbelieving themselves, being on the canvas with sensitivity and passion

The plasticity of the human figure left amazed to be able to grasp posture and forms far from the classical canons, but so real and real as to arouse admiration.

Alina Ciuciu does not just paint the human body, it is in all its pride and beauty.

Here, pride: we can say that the character of the painter is transfused in her works and the characteristics of those passions and feelings that pervade this artist so communicative that she is never indifferent to the observer but rather stimulates curiosity to know more and to want to know more about the works.

Curious, imaginative, always looking for something different but Always and only looking inside itself.

The strength of Alina's paintings is truly the fact that he is an observer

ADOLFO DE TURRIS

Born in Montalbano Jonico (MT) on 22 February 1952.

Graduated from the Art School of Milan.

Also in Milan he attended the S. Agostino Academy and later the Brera Academy with professors Terruso and then De Valle.

He was a pupil of master Arsenio De Boni, a distinguished landscape artist, and then of maestro Giovinazzo who taught the technique of Flemish painting with veiling.

MAGNANO ANTONIO

"Born 16 July 1966

He graduated from company secretary and follows a course for restaurant.

In 1990 he opened a restoration workshop and here his creativity of material and shellac was born.

His paintings exhibit and sell them in the Sicilian markets of Catania, Siracusa, Noto, Avola, Modica.

Joined the Accademia dei Leoni Lentini he performed the first group shows inspired by Van Gogh.

Basic and essential painting with the use of shellac on a wide variety of linen cloth supports, canvases, boards, canvas board, heavy cardboard, papers.

A compulsive artist, practically running one painting a day, in this he remembers Edvard Munch while in the colors he remembers his myth Vincent van Gogh

Its simple basic technique is not compromised the artistic value.

Massari Mauro

Mauro Massari was born in Castel Goffredo on 07/07/53.

A self-taught painter as a boy, he demonstrates a mastery that will lead him to exhibit in the most prestigious Italian exhibitions in the future.

Always fascinated by Dali's painting, his figurative paintings are a collection of characters and symbols of today's society.

ALESSANDRA PAGLIUCA

Alessandra Pagliuca was born in 1988 in Chivasso, in the province of Turin and moved to Lucca in 2017, where she currently lives and works. He graduated from a scientific high school with a specialization in art and decided to devote himself full time to painting and self-taught artistic experimentation.

His "debut" took place in 2012, when he exhibited his personal collection of works based on hyperrealist research and on the study of human faces and expressions. He has exhibited in different locations and

galleries both in Italy and abroad and has participated in various competitions that have seen him as a finalist on several occasions and even winner in the award announced by Elio Fiorucci in 2014.

His work is based not only on personal exhibitions, but also on commissioned works for private clients and public bodies.

Among his clients there are also Volvo Trucks and Renault Trucks Italia, for which he created a series of wall decorations at the Italian headquarters in the province of Bergamo.

"I have always been obsessed with human faces and expressions. My research initially began with a hyper-realistic style, to understand how certain techniques could express the movements of the soul. Later, however, I realized that this was not enough to say a true story, so the idea to accompany the paintings with "written proofs" was born, I added to the work pages of my novels, newspapers, letters, invoices and everything that could increase the details of the story I wanted to say .

I've always been a hyper-realistic artist and I've often tried to "break" the classical canons and move on to something more conceptual.

My favorite production is a mix of hyper-realism and conceptual art, alternating classic paintings with the pages of my favorite books, without ever taking away the pleasure of painting everything that strikes me. "

ALBERTINO SPINA

Spina Albertino was born in 1956.

His father Angelo was born in Palermo in 1923, eighteen years ago he was sent to the military barracks of Terni.

Angelo knows, Marisa 14 year old that she gets pregnant and, fifteen years old, her firstborn son, Antonino, is born.

Later the other three brothers were born, Albertino was the last child.

Last son of five, Spina Antonino the eldest son, then Salvatora, Pietro, Giovanna, and Albertino.

His approach to painting goes back to scholastic time, in the first five years he always wins the first prize in painting, then, in junior high school, the professors advise him towards an artistic school, given his skill in painting.

In the period from 1970 to 1980, he took part in several international competitions at the San Valentino d'Oro, promoted Agostino Pensa and received awards in his hometown, exhibited in Pisa (PI), in Grazzanise (LE) Perugia (PG) and with several national and foreign galleries.

In 1980 he exhibited in AMERICA in Trenton, New Jersey, where his representation of the Umbrian territory is highly appreciated by the local Italian community.

In his artistic career, his paintings are exhibited in art galleries, private and public collections.

He never abandons painting, he specifies: painting is like a beautiful woman, whom you love with all of yourself, when you think you have it in your hand, I feel new, but you can't bargain, when you paint in a forced way only for money, the artist loses contact with creativity and symbiosis in art.

Artist Luca Zogno

Zogno Luca was born in Travagliato (Brescia), where he lives and works, on 13 April 1967.

Impressionist painter he learned from his uncle Paolo Bignotti the first pictorial rudiments, influenced by the painting of Ottorino Garosio.

He began painting at the age of thirteen and later became a full-time painter six years ago.

His works are published in catalogs and specialized magazines.

He has exhibited in numerous collective and personal exhibitions.

His works are found in important Italian and European public and private collections.

BICKY SPINA

Perhaps the only Italian living impressionist

He lives in Castelletto Monferrato and has been exhibiting permanently in the Art Galleries of Lake Garda in Italy for many years.

Ileana Milazzo

Born in Palermo in Sicily (1960). Always passionate about painting, and having studied the techniques of painting techniques in the course of her work for the Department of Cultural Heritage of the Sicilian Region, she began painting a decade ago.

His exhibition activity starts with participation in the II International Art Biennale, Palermo 2015.

Use the mixed technique (oil, acrylic and collage), to create imaginary scenarios, suspended and surreal atmospheres that evoke distant eras and lost glories.

The artist in fact composes a kaleidoscope of shapes and colors by extrapolating, from their original context, images of objects, flowers, fruits or glimpses of interiors and landscapes, facades of churches and buildings and whatever else captures his watchful eye, making them the protagonists of a new story, told through their studied transfer.

The meticulous research of the compositional elements is the basis of his cultured and elegant expressiveness.

Gifted with a great inner research, he creates a language that envelops the viewer in the mysterious silence from which the residues of the past come, as in a sort of re-emergence in which everything is solemn, haughty and disarming.

A delicate artist, imbued with a profound sense of reality, in his pictorial research Ileana Milazzo wants to work beyond form.

GIUSEPPE PORTULANO

Giuseppe Portulano, born in Taranto, born in 84, currently lives and works in Bologna.

His research path begins with photography and then focuses on painting.

He has exhibited at the Unesco Center and at the Seven's.bo gallery in Bologna, at the Art Center in Basel and in the Ruspoli room in Cerveteri at the art oasis.

The research path of Giuseppe Portulano is very articulated and articulated. Experimenter of a new artistic "jargon", in his research he skillfully mixes painting, sculpture, performance, managing to obtain a complete visual synthesis.

Also in Bologna at the end of January 2018 is among the artists selected by Aldo Manzanares for the exhibition at the Circolo Arci "La Staffa" located in the alley Fantuzzi n. 5 / a. In April 2018 he was among the artists invited by the Art and Culture Association "La corte di Felsina" of Bologna, to exhibit in the exhibition "Manifesto Arte-cultura - Tribute to Giorgio Celli".

Currently some works are exhibited in Turkey in the Bipolar Artness System exhibition.

He exhibited at the Marte Cava dei Tirreni Museum at the same time as the pop revolution of Big Exhibitions Andy Warhol.

4/6 Giuseppe Portulano is an unconventional artist, able to tell contemporary time through his art and his research, thanks to his ability to tell the time of the present society through an artistic language son of a

research capable of merging languages and innovations subjects .

Without a shadow of a doubt, studioartgallery can claim to have discovered a new artistic current attributable to Giuseppe Portulano, a very young Bolognese artist.

And the "current psychophysical art"

Giuseppe Portulano's last work "La porta Rosa"

It represents the pain of Christians today, like 2000 years ago, as always.

IT IS INDICATED FOR ITS ARTISTIC INTELLIGENCE, because it is young and its prices are very low, but meets the main parameters, EMOTION AND THOUGHT in its works.

Spina Albertino

Here is an artist whose life he needs to know, his story to understand the intention to produce art.

This logic should be followed for each artist, in order to fully understand the meaning of his works. This work of knowledge can also help us to understand and distinguish the works of the same artist and the more or less successful artistic product.

Spina Albertino was born in 1956

His father Angelo was born in Palermo in 1923, around the age of eighteen he was sent to the Terni barracks as a military man.

In Terni he meets a girl named Marisa Binarelli, 13, with black hair, blue eyes and a beautiful breast.

Angelo wants this girl with the features of a woman and starts singing and serenading her home, surrounding her.

Angelo is a beautiful boy with blue eyes and blond hair, typical of the Viking who came from the south and, at fourteen, Marisa becomes pregnant and, at fifteen, his first born, Antonino, is born.

Later three more brothers were born, Albertino was the last child.

Exactly the eighth of March, it was 5pm, in Terni it was snowing and his mother, Marisa, still very young, considering that her first son Antonino said in the light when she was still very young, even if pregnant with Albertino, she played to carry the balls in the courtyard under his house, along with his other children. A story now begins to feel pains in the lower abdomen and at 18.30 at the Borgo Bovio in Terni, Albertino is born.

Last son of five, Spina Antonino the eldest son, then Salvatora, Pietro, Giovanna, and Albertino.

His approach to painting goes back to scholastic time, in the first five years he always wins the first prize in painting, then, in junior high school, the professors advise him towards an artistic school, given his skill in painting.

In his artistic career, his paintings are exhibited in art galleries, private and public collections.

He never abandons painting, he specifies: painting is like a beautiful woman, whom you love with all of yourself, when you think you have it in your hand, I feel new, but you can't bargain, when you paint in a forced

way only for money, the artist loses contact with creativity and symbiosis in art.

Zavattaro Emmanuela

Emmanuela Zavattaro was born in 1974 in Cuneo, where she lived her childhood before the family moved to Biella.

He graduated in Education in Turin and started working early in the social field.

She is an educator at a social cooperative.

Artist Luca Zogno

Zogno Luca was born in Travagliato (Brescia), where he lives and works, on 13 April 1967.

Impressionist painter he learned from his uncle Paolo Bignotti the first pictorial rudiments, influenced by the painting of Ottorino Garosio.

He began painting at the age of thirteen and later became a full-time painter six years ago.

His works are published in catalogs and specialized magazines.

He has exhibited in numerous collective and personal exhibitions.

His works are found in important Italian and European public and private collections.

Studioartgallery.it has some works by artists and others are going to buy them.

ARTISTS WE INVITE TO KNOW

There are not only me who contemporary artists to focus on, here are some names that we particularly like

DOMENICONI Simone

Creator of a new artistic line, historical based on chess.

His works, between painting and sculpture.

It still has a low price but certainly a rise.

ARRIVABENE AGOSTINO

Italian painter

Born in 1967 (age 52), a Rivolta D'Adda

VIK MUNIZ

the artist tries to explain his sense of art

"The work of art is a thin membrane that separates the real world from what we perceive"

Vik Muniz is a Brazilian artist, designer, painter and photographer (born 1961) who has made Trash the art of the distinctive trait of his creativity.

Calvin Marcus (1988)

A very young artist and painter on the international scene, Calvin Marcus is from California, from San Francisco.

Also in California, his rise to the art market began.

Sascha Braunig

is a young Canadian painter, resident resident of Portland, Maine (USA).

Sanya Kantarovsky (1982)

Born in Moscow in 1982, Sanya Kantarovsky is a young Russian painter living in New York today.

He also produces video installations and sculptures, Sanya Kantarovsky is following for his pictorial work.

Michael Dotson

L'**arte contemporanea di** Michael Dotsonreinterprets Disney characters, video games and interiors.

The price of his works is between € 2,000 and € 6,000

Nathan James

The art of **Nathan James**

His works can be purchased for € 200 or € 1,500

FIFTEENTH CHAPTER

What are the studioartgallery.it BONUSES

come and participate in the art market without any risk

Finally we have reached the point, important for us, in this not exactly economic and open market.

First of all I must say that many works by contemporary artists cost much less than the cars we drive. If one could make the huge publicity that car brands make on TV, the art market would increase turnover by ten.

Perhaps, however, understood that it is better to give up a car and in its place to buy a painting or a sculpture.

Studioartgallery.it promotes interesting artists who at least follow the rules for a work of art from good craftsmanship.

I remind you: EMOTION. THOUGHT and NEWS

What to do to help you try to buy a masterpiece?

We provide a bonus arrangement that changes value with the increase in revenue from artistic works by studioartgallery.it

The available Bonuses, for now, are and, as mentioned, reflect the sales value of the Barzaghi Collection works

At the beginning their nominal value was 50 euros.

Today their value is 57.85 euros only after a few months.

Effect of the increase in the total value of sales of the Barzaghi collection after new acquisitions.

Value determined by exclusive considerations by studioartgallery.it and its collaborators.

Bonuses can be purchased through the site.

They are nominative and numbered.

On them is VAT 22%

The holder earns interest of 7% per annum, in exchange for the right to repurchase by studioartgallery.it and its owner Barzaghi Marco

What is the right to repurchase

The exclusive right to repurchase, it is not possible to sell a bonus to anyone other than studioartgallery.it or Barzaghi Marco, and it is the right that we have to withdraw them at the last market price.

And as already mentioned, this exclusive right, for which the owner of the Bonuses cannot sell to anyone other than a studioartgallery.it or Barzaghi Marco, is remunerated with 7% a year of the value of the work, less the taxes than on of it burden.

Per vedere l'elenco delle opere e il loro valore vai sul sito www.studioartgallery.it

WHY BUY BONUS

For young or not-so-young, work is the priority these days.

Despite having a good job, however, it is difficult to have the desire to dedicate a certain amount of money to the

purchase of an artist's work, I don't say affirmed, but promising.

In any case, it is always problematic to invest in a product that bears fruit for a long and very long period and therefore has the characteristic of not being easy to sell.

Should we therefore abandon this unique and beneficial investment? Certainly not!

The solution is our bonuses.

Let's say you want to buy a work of any artist of your choice, worth 4,000 euros.

I see it in a gallery, in a trade show or in a website.

Look in our catalog but can't find it.

Are you coming? You simply have to write to us.

No problem you book it and we buy it for you.

You will pay 70% of the value of the work, even a rate to be agreed and thus blocking the price at 4000 euros.

Don't you even have a euro? No problem, start buying as many bonuses as you want and collect them.

After a year, for example, you have collected 1000 euros in bonuses but they are not enough to buy the painting you want? You can choose between three options.

One return the bonuses in exchange for their declared value on the site + 7% of rights.

Two withdraw only the rights in this case 70 euros.

Third option to exchange the rights with one or more bonuses.

Then once you get the agreed sum, in this case of 2800 euros, you can buy it by paying the balance also a fee.

It is not a simple purchase of a product in installments, because by booking with us you will block the price.

It is assumed that my purchase has not expired, the value of the painting has become 6000 euros, but you will always pay 4000, because in the meantime we will have purchased it.

Having a 50% performance in a short time and without risks, in fact, it is always a choice to renounce the purchase and keep the bonuses, or sell them to us but, this time, only at the purchase price without revaluation in the meantime occurred.

We remind you that we sell only to us at studioartgallery.it

The bonuses can be used to purchase paintings in our possession and integrated into our online catalog.

If taken in a sufficient quantity you can buy a work of art from our catalog.

You can also ask, as we have seen in the example, to buy a work of art not in our possession, as long as it is on the market for sale.

All the paintings that we compose are bought by us after the maintenance conditions and the market situation of the work.

So a great path for newbies trying to enter the world of art.

Immediately, after a year, the rights of 7% of the bonus of the purchased bonuses and this will be in absolute tranquility of being able to immediately earn by investing in Art.

In the second phase, when it is the right amount, you receive the work chosen in complete tranquility, skipping contacts with exorbitant galleries or clever merchants.

CONCLUSION

As for the problems, we can do it

The first is that the best investment at this time, but it can be said at any time and end from birth on planet Earth, is certainly Art.

The second is that evryone should have a work of art in their own home, as everyone has a refrigerator or a car, the work of art must be considered a fundamental purchase for the stability of a person's life or a family.

This is why the studioartgallery.it proposal goes in the right direction as an aid for anyone wishing to enter the world of Art.

See you next time.

www.ingramcontent.com/pod-product-compliance
Lightning Source LLC
Chambersburg PA
CBHW070439180526
45158CB00019B/1715

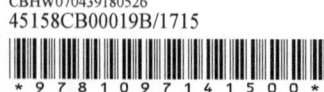